How to Paint
ABSTRACTS

How to Paint Abstracts

First English edition published in 2012 by Barron's Educational Series, Inc.
© Copyright 2010 by Parramón Ediciones, S.A.—World Rights.
Published by Parramón Ediciones, S.A., Barcelona, Spain.

Original title of the book in Spanish: *Cómo pintar abstracto*
Text: Gabriel Martín Roig
Exercises: Gabriel Martín, Myriam Ferrón, Glòria Valls
Photography: Estudi Nos & Soto, Gabriel Martín
Translation: Michael Brunelle and Beatriz Cortabarria

All inquiries should be addressed to:
Barron's Educational Series, Inc.
250 Wireless Boulevard
Hauppauge, NY 11788
www.barronseduc.com

ISBN-13: 978-0-7641-6455-2
Library of Congress Control Number: 2011923775

Printed in China
9 8 7 6 5 4 3 2 1

How to Paint
ABSTRACTS

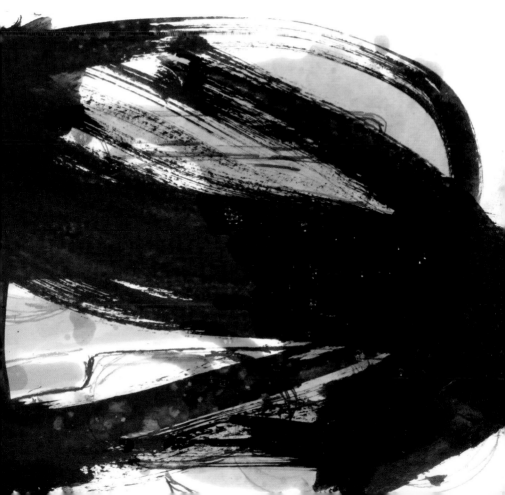

Contents

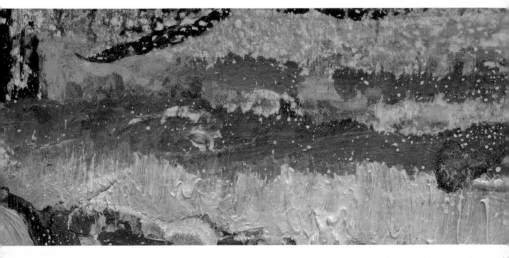

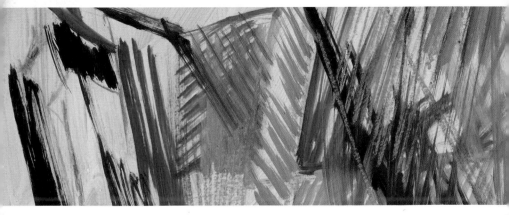

Introduction: Nonobjective Expressive Painting, 6

Nonobjective Expressive Painting

Around the year 1910 in Europe a new form of artistic expression appeared. It disregarded figurative references in favor of concentrating on the expressive strength of form and color in a work of art. It explored the essence of these basic elements without interference from clearly recognizable models. The new painting left natural forms behind and replaced figurative elements with an autonomous visual language which had its own meaning. The combination of colors, forms, and textures attempted to express emotions, a spiritual state, and specifically, the artist's interior restlessness. This nonobjective style of painting tries to distance itself from visual reality, but this distancing is rarely complete since there are many levels of abstraction.

Often people think that an abstract painting can be created by merely applying three or four random strokes of color on a canvas, and magic will do the rest. Abstraction, however, is much more than a random accumulation of a few careless brushstrokes. Although one of the main characteristics of an abstract painting is freedom, that is, the use of a formless language that is not subject to the traditional rules of painting, this does not mean that it can be an anarchic work. It requires deep understanding of color theory, total control when applying the paint, and skill with mediums that can alter paint's consistency. Furthermore, successful abstraction demands a working knowledge of composition, which can accentuate the formal and structural elements, emphasizing the boldness and expressive strength of a work.

In this book you will find out how to approach abstraction with guaranteed success. You will learn how to avoid treating abstract painting as a simply formal and decorative genre, and to see it as a symbol of modernity, a means of personal expression, a tool for the artist to maximize true creative potential, and a form of art capable of expressing the complexities of our times. This guide hopes to inspire you to leave behind, if only for a moment, your focus on conventional painting in order to explore and enjoy these alternative methods.

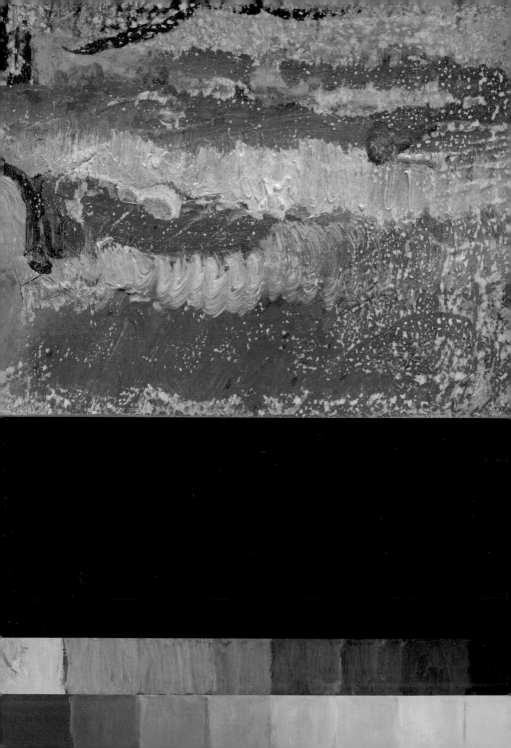

Abstracting Reality

Since many figurative artists add an abstract treatment to their paintings, it is not unusual to hear the expression "abstract forms" applied to a landscape, a portrait, or a still life. Abstraction does not appear from nowhere, it has its origin in the synthesis or fragmentation of the real world. In other words, to abstract means to purify and sum up a real model into basic units that obliterate the evidence and the original reference. Painting can be abstract in the sense that it has been "abstracted"—extracted from reality, and elevated to the nonobjective plane through a technical and intellectual process. In this chapter you will study the way an artist selects a form, and then learn the strategies that he uses to simplify the image until the original figurative reference is barely recognizable.

How to Paint an Abstract

It is possible to construct an abstract by combining forms without paying attention to any particular subject or figurative reference. However, if you have never done an exercise in abstraction it is better to start by referencing a real model. Natural forms are a very productive source of pure images.

Abstraction, as opposed to pure abstract painting (where there are no recognizable references to reality) consists of choosing elements from the visual world to create a very synthetic representation. Here, one does not worry about representation in the normal sense of the word.

A careful synthesis of any subject ends up transforming what was initially a landscape into an abstract composition in which references to the original subject are lost.

Studying Forms

Still lifes and interior scenes are very useful points of reference for exploring abstract forms and their relationships. Each element is synthesized according to a basic geometric form and the generic color that it is known for. With this simple substitution, the figurative elements are barely recognizable while the composition and the distribution of the forms take on more importance.

As Seen from Above

Just a change in the point of view should be enough to create an interesting composition that will bring us near abstraction. For example, when a model is observed from above a strange sensation occurs—one that distances you from the objects and emphasizes the geometric structure of the forms. The composition is thus read as a group of abstract forms even though most of them are easily recognizable.

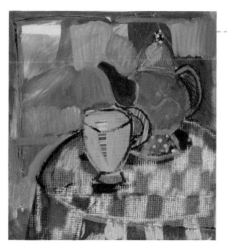

Still lifes are a good starting point for studying abstraction, since they usually consist of simple forms that can be painted with bright colors.

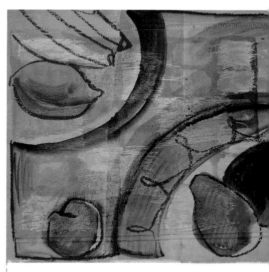

Just by changing the point of view and cropping the framing a new view of the real model emerges, one that is forced and much closer to abstraction.

Synthesis and Analysis of the Model

Objects are detrimental to painting, because we pay more attention to their details, textures, and reflections than to their essence. The process of abstraction begins with purifying the forms, or synthesizing the elements of the reference model. It is important to avoid focusing on detail in order to capture the spiritual essence of the forms using loose, imprecise brushstrokes.

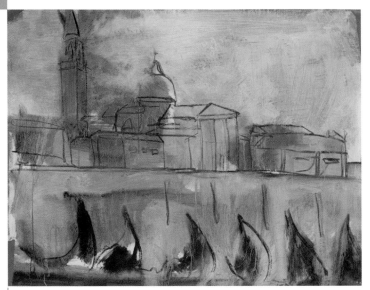

The first step towards abstraction *is to represent the model with areas of diluted paint combined with graphite lines.*

The forms are purified and made more artificial. *Keep the most meaningful shapes.*

Dilution and Fracture

Artists pursue different strategies for abstracting the forms of a figurative model; the most common one is related to dilution, change, and fracture. That is, they attempt to break the unity of the model into smaller units of shape and color. Other strategies for synthesizing can also be used, like reducing the number of colors on the palette, using brushes that are not suited for painting details, and employing a quick, vigorous approach in the execution of the work.

Cropping the Frame

Another way to exploit a real model in search of abstract approaches is by cropping the framing so that the objects are barely recognizable. Paying close attention or zeroing in on a detail or particular characteristic of the object will allow you to lose sight of the overall model.

Abstracting the human figure presents greater challenges than any other subject — *this is because of the difficulties in removing oneself from it to the extreme of treating it as a group of forms. The best approach is to avoid viewing it as a single form and fragmenting it into several brushstrokes that break up its shape.*

Inspired by the previous two notes, we painted an abstract composition in which the form and range of colors were strengthened. A few graphics were added to give it more interest.

Gesture Painting

As soon as a child is able to hold a pencil or brush in his hand he begins drawing lines and circles in all directions. His arm moves violently, leaving incised lines all over the surface of the paper. Recalling this particular early-childhood motor movement can help us explore our own gestures, as we cultivate a desire to explore and learn to relate our arm movements to the feelings of our subconscious.

A gestural line can be created by brushing heavily diluted paint on a white support, varying the lines and approaches, repeating them with unexpected changes in shape and direction.

You must work with abstract symbols that are completely free of any conceptual meaning, created with purely imaginative and improvised actions.

Gesture Exercises

Whereas the process of synthesizing a model is based on the rational study of a form, the gesture approach relies on impulse and sensation as the basis of creative expression. The line follows the sudden movements of the forearm, which moves very quickly so that the artist has no time to reflect on the direction and orientation of the gestures of the brush.

Freeing the Subconscious

Gesture painting lets the artist be extremely spontaneous and agile with the brush. This does not mean that you must work in a frenetic manner. You can begin with a gesture, pause, and then decide how to continue the image from there. Gesture painting can be very therapeutic since it helps relieve tension and lets you lose yourself in the apparent chaos. This impulsivity liberates the subconscious and frees the vital energy that emanates from the emotions and personality of the artist.

The process of gestural painting is more important than the final product. Large formats are preferable since this type of painting is so focused on the action of the painter himself.

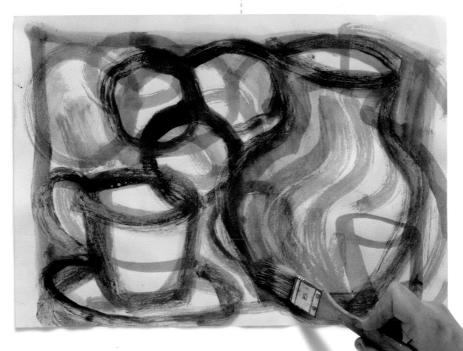

Dripping and Splashing

The unpredictable nature of splashes and drips becomes yet another resource for the painter of abstracts. Uncontrolled applications of paint, running across the inclined surface of the support, add interesting esthetic effects that accentuate to informality, carelessness, and the lack of control over the form. Furthermore, they communicate the idea of lightness and fluidity.

Paint colors are applied to a flat support, but the paint can distribute itself in an irregular manner.

You do not have to wait for the drips to appear spontaneously, they can be helped along deliberately.

Colors can become more textured by combining two mediums that are seemingly antagonistic, like turpentine and water-based paint.

When turpentine is combined with india or sepia ink, the fragmentation of color is even more evident.

Dripping on a Flat Support

When working with color washes you have to abandon vertical painting on an easel and lay the canvas flat on a table or the floor. This way you can walk around it and work from all sides and the diluted colors can be applied in a more controlled way. If a dripping effect is desired, all you have to do is lift one side of the support to create an inclined surface that the paint will flow down.

Splashing

Drips and splashes are the result of quick gestures, and they are a response to the need for greater expressivity in a work. They reflect a certain lack of control, and break from purity and order as if the force of the paint has escaped all control and exploded in a riot of color on the canvas. It is pure imaginative and improvised action. The effects vary according to the quantity and consistency of the paint.

You can create fanciful shapes by just blowing on the dripped paint with a drinking straw.

You can create a composition using just splashed paint, but it is more typical to employ this technique to create a particular effect in only certain specific areas of the painting.

Geometric Synthesis and Fragmentation

Geometric forms supply the artist with some very solid tools for transforming a model into an abstract representation. Simple forms like cylinders, cubes, cones, spheres, and rectangles, always associated with the simplification of the form, guide a large part of abstract art. Forms observed in nature are simplified when interpreted geometrically.

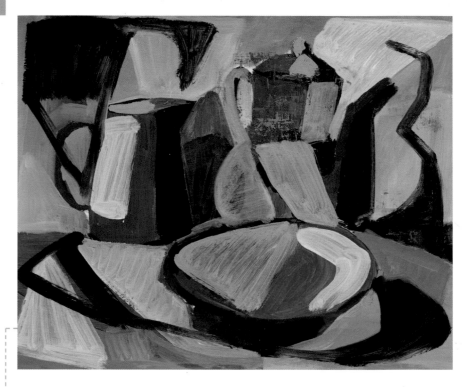

Fragmenting the model into simple forms is the first step towards abstraction. Color is another important player, used for adding contrast.

A Necessary Process

Cubism pointed the way to simplification of the form using geometry. The process is simple: summarize the model in simple geometric forms to achieve its purest representation. Cubism's main characteristic is the deconstruction of forms and figures into multiple parts, fragmenting a scene. Models are analyzed and reorganized into separate elements.

The Use of Color

Abstraction through geometric synthesis can be considered an exaggerated exaltation of the two dimensions when it is compared to the strength of other abstract currents that try to enhance the three-dimensional effects. This is done by reducing form and color to their bare essences. In doing so, the painting becomes a space for experimenting with the relationships among lines, colors, and the different planes, which are converted to the structural base of the work.

Form and color reveal balance and unity. They become primordial categories in compositions where the geometric elements have great importance, and they are able to create new, non-figurative realities.

Geometric synthesis works more effectively when the structure of the painting is based on simple forms. Brief notes or sketches can be made as exercises for the geometric representation of the real model.

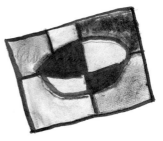

How to Make an Abstract from a Real Model

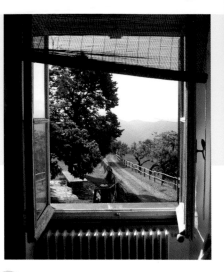

A window opening onto a landscape makes an ideal subject for embarking on our first abstraction exercise. This one was done by Myriam Ferrón.

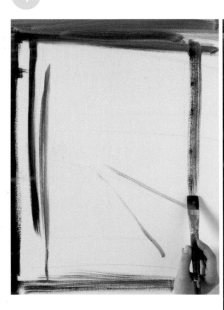

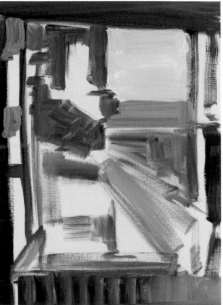

1. *No preliminary sketch is required. Taking a wide flat brush, the artist very quickly lays out the window frame with raw sienna and titan blue, both very diluted.*

2. *The next brushstrokes are applied using cerulean blue, pink, and titan green, more or less following the distribution of colors in the real model. The strokes are wide and applied as blocks of color.*

Even though pure abstract paintings seem to have no connection to the real world, something that the artist has seen or experienced is almost always used as a point of reference. This exercise is a good example, and it demonstrates how the making of an abstract begins with a rational process of creating forms. We begin with a real model with clearly defined elements, and proceed to deconstruct them using large strokes of color and geometrized forms. This step-by-step exercise was done with oils.

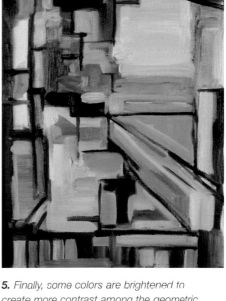

3. New brushstrokes are applied over the previous colors to give the painting greater richness. We never stop using the wide brush, which keeps us from getting caught up in the details.

4. After the white paper has been covered with the first layer of colors, we take up a finer brush. The goal is to create contrasts using intense blue and brown colors, making lines and strokes with a clearly geometric feeling.

5. Finally, some colors are brightened to create more contrast among the geometric shapes in the center of the composition. The abstraction is complete; the subject will only be recognizable to someone who sees the photograph.

Paul Klee
(1879–1940)

Paul Klee was one of the main proponents of geometric abstraction.

Main Road and Side Roads *(1929). This work is from Klee's abstract period. It is very fragmented and divided into different colors creating a restless network. The arrangement, the angles of certain lines, and the staggering of the colors communicate a very strong sense of calm.*

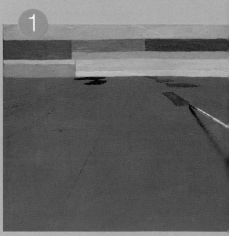

1. *To recreate Klee's style we begin by covering the background with a layer of red orange. Geometric shapes that divide the surface of the painting are drawn with graphite. From here we begin to fill in the spaces with uniform layers of paint.*

2. *We use a wide range of colors to paint the geometric forms that cover the surface. When working with acrylics the colors should be mixed with a little white to make them more opaque.*

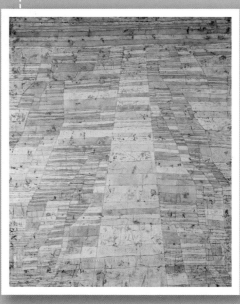

SYNTHESIZING FORMS AN

Paul Klee truly exploded onto the painting scene beginning in 1914, when he made a brief trip to Tunisia with his friend Louis Moilliet and August Macke. There he learned to synthesize forms and colors and take his representations to a first level of abstraction. The next period, when he was at the Bauhaus school, is distinguished by a geometric style and painstaking attention to color—here, he learned to systematize his artistic language and in doing so, became one of the creators of modern abstract art.

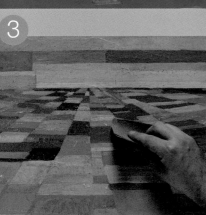

3. After the entire support is covered with paint and the original orange is no longer visible, the surface is rubbed with fine sandpaper. This breaks up the uniformity of the areas of color.

4. Sanding allowed the orange to show through the overlaid colors in a very subtle manner, and gives the painting a worn and ancient feeling. It definitely adds greater visual interest.

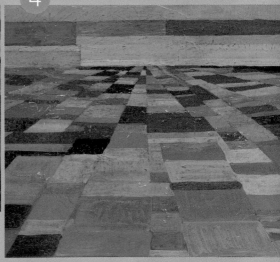

COLORS

Composition Is Key

Don't be fooled by your first impression. Colors and forms are not placed randomly when painting an abstract work; everything is based on a studied arrangement of the elements, which is governed by a few rules. In no other genre of painting is composition so important; it is vital to the way we perceive and interpret the abstract images.

The natural focal points surround the center and cover about two thirds of the painting.

The focal point is the red color located about three quarters of the way up the painting's surface. It is surrounded by forms that direct the viewer's eye towards it in an interesting manner.

Horizontal lines add greater space and depth to a painting.

The verticals add rhythm and strength.

Diagonal lines are associated with dynamism.

Using the Focal Point

The focal point refers to the place where the viewer first fixes his or her eyes on a painting. For comfort, the natural focal points are found near the center, covering about two thirds of the surface if we divide it with a diagram of crossed lines. For a painting to be more attractive, two or three lines or striking forms of different sizes and chromatic values can be placed at the focal points or near them. This prevents the main elements of the painting from always being concentrated in the center of the composition.

Directing the Eye

Areas of color are usually combined with lines and brushstrokes that direct the eye of the viewer across the surface of the painting. It is as if paths are created for the gaze to follow. It is an unconscious act; when our attention is attracted by a figure constructed with a line, we tend to follow it. Horizontal lines give the impression of space, verticals are more imposing, and diagonal lines are more dynamic feeling. It is important to choose the most appropriate lines depending upon your intended outcome.

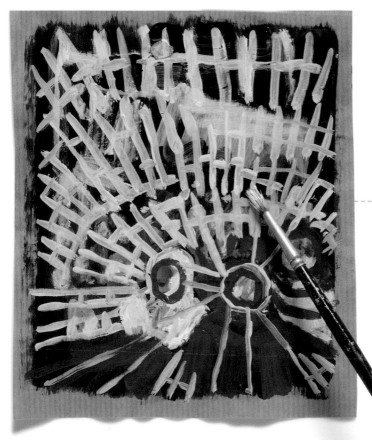

Another interesting compositional strategy consists of arranging lines or brushstrokes towards the focal point.

THE SUBJECT

Grouping and Spacing

In addition to the composition of a work, it is important to pay attention to the distribution of forms and the intervals or spaces that exist between them. You should create groups of similar elements to make them easier to read and to keep the painting from becoming static and boring.

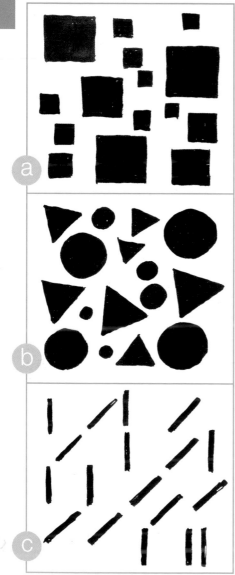

The viewer tends to focus on larger forms, so smaller forms play a secondary role.

Similar forms are easily grouped into sequences, which means that the eye reads the triangles together and later goes on to do the same with the circles.

Grouping forms by orientation means uniting elements that are aligned the same way.

The order and distribution of the elements in the painting can be reinforced with chromatic sequences in the shape of an X that directs the eye and adds dynamism to the painting.

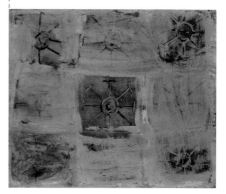

A Network of Elements

If several motifs or areas of color are separated from each other in the space on a canvas, but they have certain affinities, similarities, or common characteristics, the viewer's eye will jump from one side to another so that they will be perceived as a network or constellation. These associations are very common in painting and can be understood through the phenomenon of visual grouping.

Relation of Similarities

Figurative references disappear in abstract painting, so that each aspect of the work (color, effect, texture, form) is associated with others with the same characteristics. They can be grouped by similarity in size, form, placement (tilted, aligned), orientation, tone (brightness), color, texture, or quality of outline. Artists can use these groupings consciously or spontaneously to create balance, a sense of order, or dynamic rhythm.

***Grouping by color** is effective, and constitutes an approach to composition that cannot be ignored.*

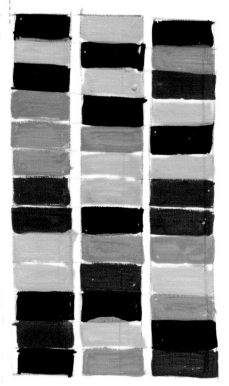

***Composition can be used** to destabilize the surface by creating pulsing fluctuations, modifying the forms so they can be understood as intervals that break with regularity.*

Experimenting with Colors

In abstraction, color is manifested in every possible way imaginable. The description of volume is no longer the main objective, and therefore color becomes an autonomous element that needs only represent itself.

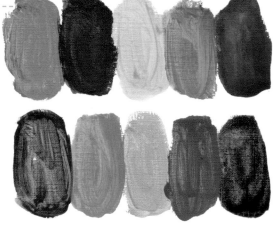

Before beginning to paint it is a good idea to study the range of colors that will be used. The colors in the top row will be used to create a very bright and strongly contrasted painting. If using the colors in the second row, the harmony and integration of forms will be greater.

The unifying effect in abstract paintings is more effective if harmonic color ranges are used. It is helpful to practice with them separately.

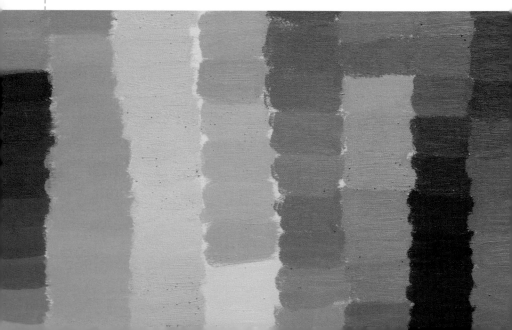

Multiple Functions of Color

Color is used to command attention and to make any element in a painting stand out. It keeps a painting unified by establishing associations, and by suggesting or creating atmospheric effects. Along with brushstrokes, color also creates the illusion of movement. In nature, light creates movement in color; to replicate this, it is necessary to master artful techniques for applying color (through brushstrokes, mediums, etc.) to achieve successful expressive results as well as descriptive ones.

Chromatic Delirium

Without a doubt, the main characteristics of abstract painting are the use of language without form and chromatic freedom. Traditional color theory can be adapted to all kinds of imagined things. The end justifies the means. However, to be able to apply colors freely and intuitively it is a good idea to have a firm grasp of certain concepts, for example: making use of color synthesis, developing intuitive thought, practicing modulation in all possible shades, and mastering composition, expression, and the construction of forms using colors.

If you use colors of similar intensity and tones, harmony is guaranteed and contrasts will be subtler.

The use of saturated colors, immersed in a strongly colored whole, achieved through bold applications of mixtures and overlaid colors, will result in a very dynamic painting.

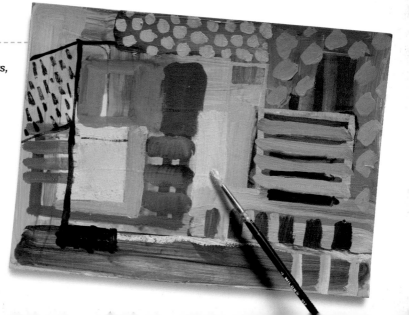

Painting a Feeling

In contrast to figurative work, which is thought of as representing the world, abstract painting often represents the interior state of the artist. Here, emotions are important, and they are translated into visual chords composed of line and color in the painting. In this chapter we propose a simple method of exploring our own feelings and expressing them through an abstract painting.

When representing feelings it is important to forget social conventions. For example, do not presume that pink is the color of love and that gray suggests sadness. You must try to discover in your own mind's eye which forms and colors suggest those feelings to you.

Select the samples or experiments that are most suggestive to you. (From top to bottom: loneliness, nervousness, and pain.) Make your own samples in a larger format.

Preparing the Sample

Before starting the work session it is a good idea to prepare a couple of sheets of paper for samples and have them at hand. Two simple cardboard pieces will be enough for you to draw six circular shapes on each of them. The base of a glass can be used to quickly and easily draw the circles. Lay out some brushes, wax crayons, color pencils, charcoal, acrylics, and a selection of drawing tools on a table and you will be ready to begin.

Painting Feelings and Music

On the first sheet, inside each circle, try to express the following feelings with abstract lines and shapes: love, hate, nervousness, loneliness, envy, sadness, pain, and pleasure. On the second sheet the exercise is repeated, but this time experiment with music. Paint the feelings you get from the following types of music: jazz, classical, disco, tribal, flamenco, new age, techno, and Far Eastern. You can also create different reactions to the music that you have at home.

When painting the samples in a larger size it is not necessary to be strict with the colors, but you should conserve the initial spirit.

Ultimately, a small note of color revealing internal feelings ends up transforming itself into a very defined and elaborate abstract painting.

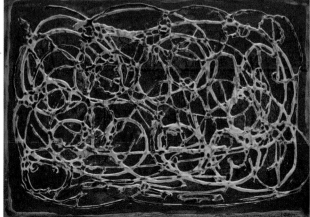

Working in Series

There are many artists who have adopted the technique of working in series, which allows them to create numerous versions of the same model until they arrive at one that satisfies them. Working on any representation by developing a repetitive series allows you to analyze the composition more rigorously and carefully study the

① First Stage

You must create variations of the composition that will help you decide how to handle the empty spaces.

The first applications *help you determine the composition and the distribution of the main elements.*

Gradually make the forms more abstract *until you have distilled them into what you consider to be their essence.*

elements that make up the work. To help you better understand this working process, here is a simplified example that illustrates the evolution of the forms in the painting from the first brushstroke until completion.

② Second Stage

Starting with graphic elements and experimenting with colors, several compositions are painted that allow you to study the possibilities as you continue to create similar versions.

Working in series encourages a purification and progression in the representation of the subject. Here is a first representation done with colored pencils and gouache.

③ The Final Work

When the previous version is deemed acceptable, it is then painted on a larger support with acrylic paint and India ink.

What Is Deconstruction?

This contemporary term refers to the act of destroying one or several paintings and utilizing the pieces to construct a new, more expressive one. This is a very effective creative process that allows the artist to learn to select and combine forms. In deconstruction there is great control of the creative process and the resulting abstract painting will be the product of a process of deep reflection. Deconstruction allows you to experiment, trying different options before committing to one; and, therefore, your final results will be much stronger and surer.

We are going to practice deconstruction by making several abstract paintings.
For this you must gather fabrics, paintings, and sketches (even figurative ones) that you have done in the past, especially ones that you like, and also any color studies that you have set aside.

Cutting and Pasting

Put a group of old paintings that you like on a table. Try to identify abstract forms in fragments of these paintings. Cut out the areas that attract your interest, whether for their colors or for some specific effect. Spread the cut out pieces on the table to analyze them, and try to find possible combinations among them, so that once they are together they create a new abstract composition.

The cutouts can be combined in a thousand and one different ways until finding a combination of colors that you like

If you use small cutouts from reversible figurative paintings, you will discover unknown aspects, which can be assembled to make a new abstract composition.

The small abstract paintings created from cutouts can be glued to a piece of cardboard. They are small notes of color that can later be recreated on a large format canvas.

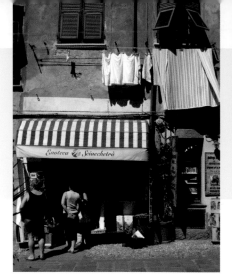

LET'S EXPERIMENT

Lyric Abstraction

Glòria Valls takes us through this exercise based on lyric abstraction, where the process of synthesizing and abstracting the model is not as

This facade contains a wide variety of different overlaid forms and colors. It is rich in contrasts and surfaces with different characteristics.

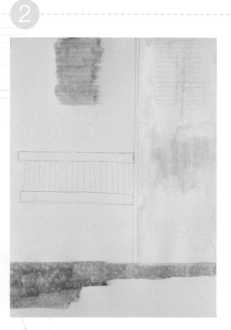

1. *A few lines are drawn using graphite to sketch out the structural elements of the model in the photograph: the awning over the store, the drainpipes on the facade, and the shutters.*

2. *The applications of color are large, flat, and diluted. She has chosen a range of greens that have nothing at all to do with the colors of the model. She works at covering the white of the paper as quickly as possible.*

rational as that of the previous step-by-step exercise. There is not as much interest here in capturing the geometric structure or breaking the model up into blocks, rather the focus is on the free use of colors and the expression of the painter. A color's expressive and symbolic qualities become more important. This will be a more poetic and emotional work, where the colors blend softly. The applications and mixtures are more expressive. The fluidity of acrylic paint is ideal for creating these effects.

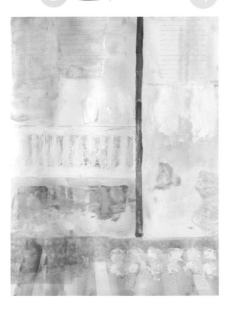

3. The surface is completed with new applications of green and orange. Valls lets herself get carried away with the colors that she most likes and that are meaningful to her. The shape that is inspired by the awning over the storefront is done in white paint with a metal spatula.

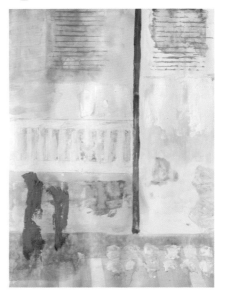

4. Strokes of white, green, and yellow acrylic paint are applied in the area that corresponds to the hanging bed sheets, the inside of the store, and the door of the house. They have irregular shapes since they were made with a spatula.

5. The parallel lines representing the shutters are scraped with the edge of the spatula. Two thick strokes of red paint representing the figures are applied with a brush. Since red is the complement of green this creates a strong contrast.

6. In this last phase, the artist attempts to further remove the painting from a representation of the real model. This is done by including new symbols and forms that enrich the painting. There is an emphasis on creating signs and forms that embody spontaneity.

7. The superimposed forms are made with denser paint, and they are enriched with new shading and brushstrokes that help add more graphic variety to the painting.

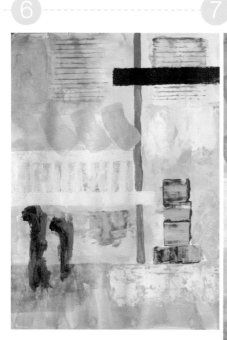

8. The newly added elements cause the painting to lose the references that associate it with the original photograph. Now it is a matter of the artist allowing herself to be carried away by her own senses while adding diversity to the work.

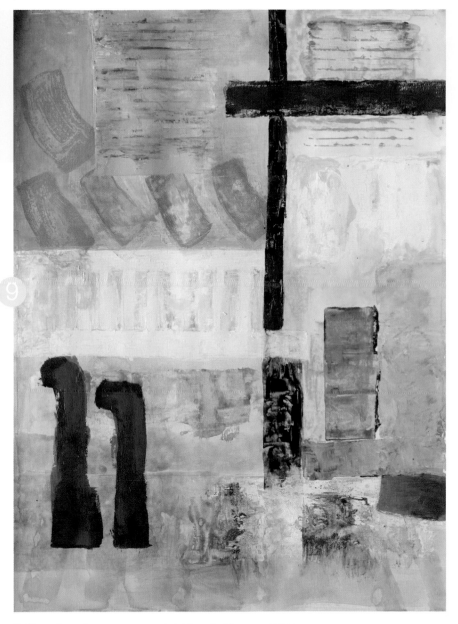

9. The colors of some areas are brightened with new washes. The most opaque areas are applied last and they reinforce the solidity of the rectangular forms. Notice how corrections have even been made; for example, the layer of green paint at right that covers some orange brushstrokes that did not satisfy the artist.

Robert Delaunay
(1885–1947)

Delaunay successfully represented the circular movement of light with a combination of bright and saturated colors.

Circular Forms, Sun No. 3 *(1912)*

Delaunay loved rhythm and movement, and he painted several works based on the representation of light. He was inspired by the rays of the sun and the incorporeal glow of the colors of the rainbow. Using a very wide range of tones and paying heed to color theory, he represented different facets of light: its expansion, energy, transformation, and immateriality.

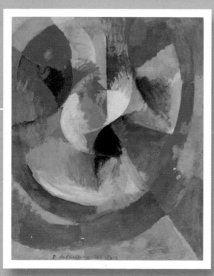

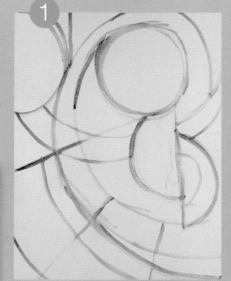

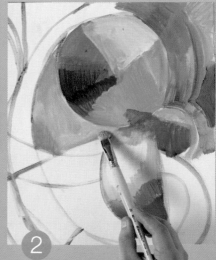

Delaunay started out as a Cubist, but he soon abandoned that style to focus on a new one dominated by circular forms and bright saturated colors, based on the juxtaposition and simultaneous contrast of pure colors split in prisms. The main focus of his paintings was the representation of light and the chromatic effects that derive from it, which culminated in impressive abstract works full of geometry and rhythm. His oils acquired a dynamic character based on breaking up the color wheel, since he was greatly interested by circular forms and rotational movement.

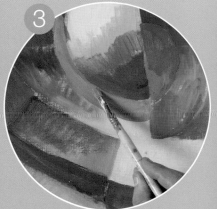

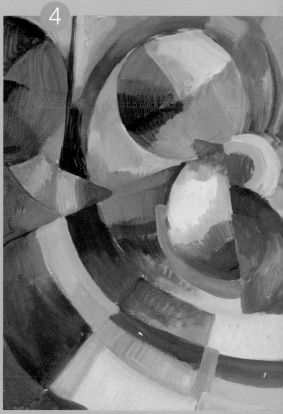

1. Here there is no need for a preliminary drawing to create the circular forms. A few lines made with blue diluted with water are enough, since the exercise will be done using acrylics.

2. Each area of the painting is covered with pure colors, either directly from the tube or barely worked on the palette. As they are juxtaposed, they are slightly mixed with each other to make gradations. It is not necessary to place two similar colors next to each other; on the contrary, the more different they are, the greater the contrast.

3. The areas where brushstrokes can be seen are combined with others where the paint looks flat. Quick drying acrylics let you modify the colors and overlay paint without accidentally mixing it.

4. The succession of rhythms represented by colors developed through the rule of simultaneous contrast results in an abstract work where color and the dynamic effect of the composition take on great importance.

Abstract Techniques

Abstract painting allows you to combine the most diverse and even contradictory media on a single support with total freedom, and in a lively and viable manner. It becomes an interesting bank of experiments, including textures and effects that are not generally used in other genres. It is important to experiment so you can enrich your paintings, to overcome the fear of combining media and materials that are seemingly incompatible. These experiments should first be done on a separate piece of paper, and then, depending on the results, applied in a more ambitious work. This work of researching different techniques can be a liberating experience, not only for amateur artists frustrated by their lack of skill, but also for professionals that heavily depend on a specific medium or technique.

Rayism: Painting in Motion

Rayism is a very simple and effective technique. It consists of illustrating the look of rays emanating from an object and the rapid and simultaneous propagation of light. In this way, the "rays of color," organized in rhythmic and dynamic sequences, construct a pictorial space.

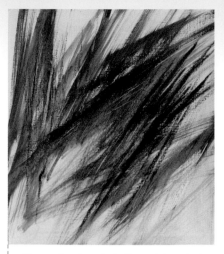

Lines of colored chalk are integrated with the brushstrokes of acrylic or oil (whichever you prefer). It is a good idea to vary the angles of the lines.

You must practice the brushstrokes before painting. They should be straight and made very quickly.

After practicing the ray lines, the first compositions can be made on a support with a uniform color.

Laws of Dynamism

These laws are based on compositions constructed from rays of light that cross and dissolve into motifs that constantly change. In rayism lines and linear brushstrokes flood the surface of a painting. When arranged on the canvas in varying lengths and intensity, they suggest an unreal universe, ruled only by dynamic and chromatic laws. A sequence of straight brushstrokes arranged on the surface suggests movement, which can be increased if they are overlaid with a rotational effect or with a series of very tightly spaced gestural brushstrokes.

Rayism with Brushstrokes and Lines

In the following exercises, brushstrokes of acrylic colors are combined with lines made with charcoal and chalk. It is important to draw the lines over wet paint so they will be mixed when it dries. The drawn lines act as a counter-point to the painted brushstrokes and convert them into a mass of action lines. This creates a feeling of movement since they are tightly grouped.

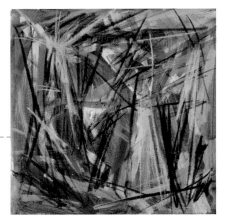

The effect of movement on the surface of the painting is perceived by consecutively observing the strokes or lines in different positions or overlaid at different angles.

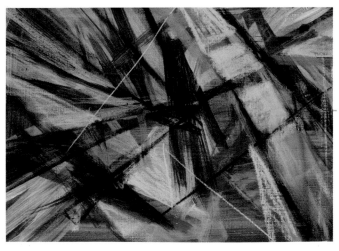

The forms should not be identical, nor should the lines be at multiple angles.

The Value of Texture

Texture lets you highlight the tactile quality of the surface of a painting. It is usually added to create a graphic richness, and it is very important in abstract and semiabstract treatments. When we leave the strict representation of objects behind, we need to recreate interest through the treatment of the surface. Then, by manipulating the color, the forms, and the texture you can accentuate the existence of the paint as a subject.

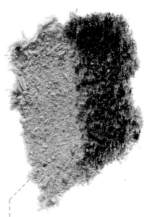

Fine sand *mixed with latex.*

Carborundam *agglutinated with latex.*

Sawdust *finely pulverized, with latex.*

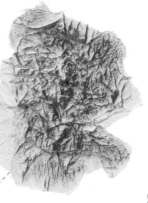
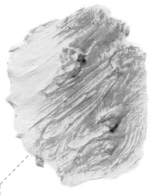

Relief effect *created with wrinkled paper glued with latex.*

Impasto *made with gesso.*

Types of Fillers

Fillers are solid substances that are added to paint to create relief and texture, altering granularity but barely affecting the color. The most common and effective ones are marble dust, pumice powder, carborundum, and sand. In fact, any ground substance can be added to the paint, but it is a good idea not to add organic or biodegradable materials like sugar, salt, or flour. To make a well-compacted mixture that has some body, add a paste such as oleopasto, gesso, or latex. All these are readily available in art supply shops.

Two Methods of Working with Texture

One way is to first apply a primer with gesso or latex and marble dust to the support. This will create a surface with relief upon which, when dry, you can paint with oils or acrylics. Another option consists of mixing substances or fillers directly with the paint, before applying it to the support. Only media with strong agglutinates, like oils and acrylics, can accept fillers.

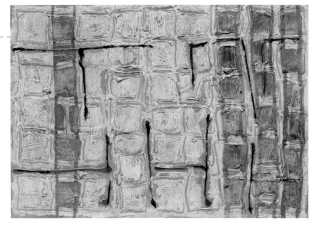

The surface of the painting is heavily covered with gesso on which sgrafitti was added. After drying, it was painted with diluted oil paint.

It is a good idea to experiment with different fillers and agglutinate materials, and then save them to remember their effects, like sample cards.

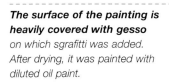

Painting with Fillers

Animals are interesting subjects for treating with textures.

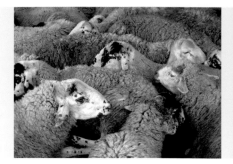

S U R F A C E S W I T H V O L U M E

①

②

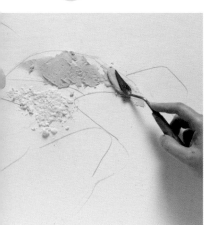

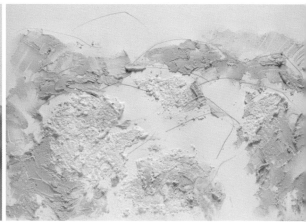

1. After a preliminary pencil sketch, the first applications of modeling paste mixed with very fine and course marble dust are added. The work is done with a metal spatula.

2. The surface of the support is covered, alternating among modeling paste with fine grain marble dust, heavy grain dust, and fine grain volcanic sand, which is black. The superficial relief that is required in each area is created with the tip of a palette knife.

Working with mineral fillers, like marble dust, mica, carborundum, and pumice, adds significant volume to the surface of the painting. This is a direct modeling technique in which the relief is created on the surface before it is painted. This results in a rough surface to paint on that will later create different shades, and help your work achieve greater visual impact and expressiveness. Techniques that incorporate fillers are best used on fabric, heavy cardboard, or canvas board, because a weak support runs the risk of warping. This exercise was done by Myriam Ferrón.

3. The modeling paste is allowed to dry for a few hours before beginning to paint. The first applications of color are very diluted gray tones. The upper part of the support has been left smooth, with no modeling paste on it at all.

4. It is a good idea to use brushes with stiff bristles, and better yet if they have long bristles which can carry a greater amount of paint and pigment. Paint that is a bit diluted flows better over a textured surface.

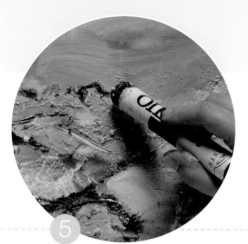

5. Lines are drawn with an oil stick in the upper part of the painting. In abstract paintings it can be very effective to alternate different approaches and graphic effects in the same work.

6. The colors look whiter and they blend with the previously added grays. Some textured areas are left unpainted—it is not necessary to completely paint all the modeling paste, it has its own coloration that will end up being incorporated into the painting.

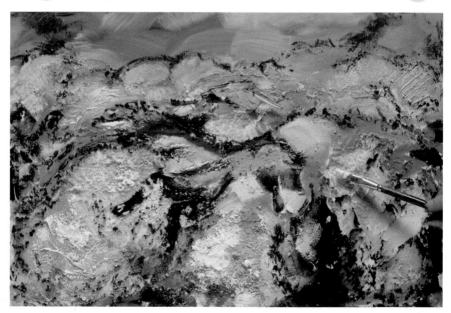

7. After the surface has been covered with a harmonic range of greenish-grays, more graphic variations are incorporated into the work by painting winding lines of bright red. The brushstrokes are thick and very saturated with color.

8. The painting's shapes, light, and intonation of color are inspired by the real model; however, any references that are too figurative or literally suggestive of sheep are avoided. Attention to color harmony is most important—as is the incorporation of the precise red lines that add variety and expression.

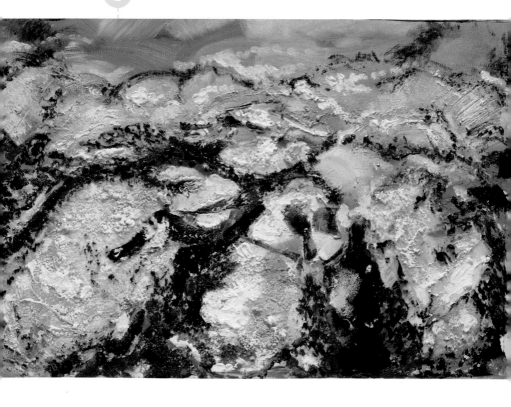

EFFECTS

Different Textures

For more ways to approach your work, we present here a group of varied and creative textures that will add a bit of visual interest to abstract paintings. All of them can be purchased with the filler already mixed in at the art supply store, although if you prefer, you can make some of them by mixing the filler

Fine textured gel. The filler is a fine grain marble dust agglutinated with an acrylic medium. It is fast drying and adds a light granulated texture.

Light modeling paste. This creamy substance is easy to manipulate with a spatula. Its white color makes it easy to integrate into the canvas.

Heavy textured gel. This acrylic preparation has larger grains of marble. It creates a very abrasive surface, and it does not work well for modeling forms on the support.

with acrylic gel or latex. You should
always use a spatula, never a brush.
There is a danger of using too much
of these textured media on a painting,
so it is a good idea to somewhat limit
their use.

*Normal matte gel. This is a very malleable paste with a
translucent appearance. It is ideal for creating volume
without leaving spatula or brush marks.*

*Heavy grain pumice stone. This is used as a substitute
for marble on large format canvases because it weighs
much less.*

*Medium grain volcanic sand. It is also lighter than
marble; however, its black color makes it difficult to
use with transparent layers of paint.*

Adding Collage

Collage challenges the artist to think about an original concept for an image in order to come up with a very fresh looking result. It adds an interesting surface to work on—very different from the traditional white background. You do not have to settle on a single kind of paper; in fact, you should combine several different ones, and even include printed fabrics to create different colors and textures.

Select papers and cut them into the required shapes. It will be easier if you try different combinations on the table or work surface.

Glued paper with straight cut edges appears more calculated, structured, and striking.

Torn paper is more accidental and expressive.

Paper can be treated with oil and varnishes to intensify its color.

Thin papers treated with oil can be superimposed on drawings like a glaze.

Cutting or Tearing

When using paper as the primary material, it is important to consider whether you are going to cut it or tear it, because the contrast between the edges of cut and torn papers can greatly change the work. A figure or an edge that has been cut has a definite and deliberate look, and conveys an air of authority, while at the same time adding more definition and stiffness. Torn paper can be more organic, expressive, suggestive, and lively.

Completing the Painting

The logical order is to make the collage and then later paint on the paper. This allows you to complete the different kinds of edges and forms in the piece with colors. The graphic contrast between the brushstrokes and the background will give the painting a very attractive finish. The paper can also be treated with oils and varnishes to create more intense colors, greater contrast, or transparent effects, especially if the paper is white and very thin.

Collage requires composition, combining colors, and attention to visual elements. Much more than a simple combination of pieces of paper, collage is the essence of the creative process.

The painting is done on a background prepared with different pieces of colored paper. The result is more colorful and has greater graphic variety.

Lines and Structures over Collage

The almost frenetic layering of these numerous facades is the source of inspiration for the following work.

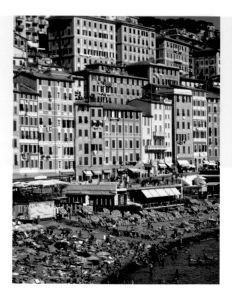

1. *The white canvas is covered with papers of different colors that are attached with white glue or latex. It is preferable to tear the pieces by hand than to cut them with scissors.*

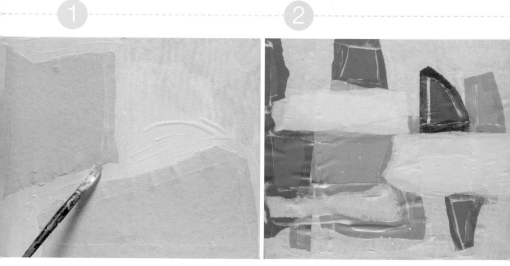

2. *It is not a matter of randomly gluing on pieces of colored paper. They must be composed so that the final result is an attractive layout. The chosen colors should harmonize and not clash too much.*

3. *When the glue has dried on the collage, linseed oil is applied to the papers to intensify the colors.*

4. *The paper is allowed to absorb the linseed oil for a while. The canvas should be flat on a table, and muddy turpentine brushed over it so it can be absorbed along with the oil. This will keep the color of the papers from becoming too bright.*

Collage is a technique that works well to hide the white of a canvas, and it also creates a base of color, which is already abstract, that is very easy to work on. This exercise was done by Gabriel Martín, who tried to transform a figurative model composed of building facades into an abstract work painted on a colorful background made with collage. The juncture of the two languages—large zones of color made with torn paper combined with striking linear structures painted in oils—is the key to its success.

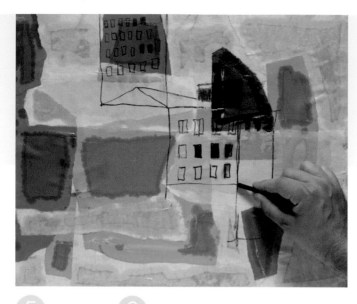

5 — 6

5. *Remove any extra turpentine and oil that has not been absorbed into the surface using lots of paper towels. Then you can begin to paint. Draw the structural lines of some of the facades with a black Conté crayon. These are purely for orientation and do not have to accurately depict the real model.*

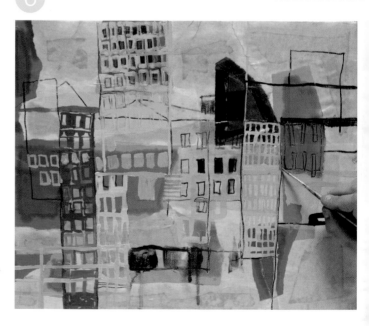

6. *Begin filling in with thick oil paint to reproduce the color of the scene. The facades should be synthesized with small rectangular forms.*

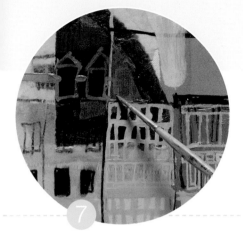

7. *Some of the architectural elements, like the doors and windows, should be suggested in a very synthesized manner. Any details should be avoided so you can concentrate on the fluidity of the brushstrokes.*

8. *The color chosen for painting each facade should be based on the color of the paper underneath. The goal is to create contrast. Extend the lines of the buildings to the edges of the canvas, as if the forms were expanding to flood everything.*

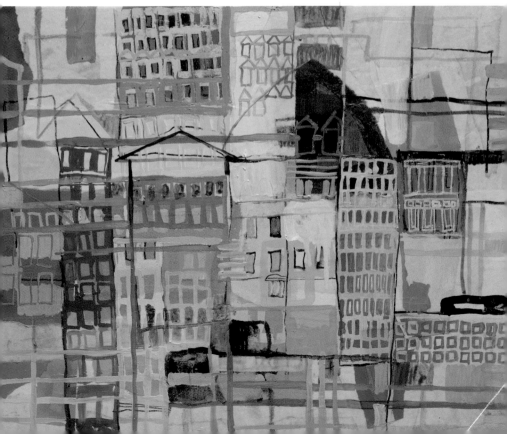

Action Painting and Dripping

The most striking product of Abstract Expressionism is the technique known as *action painting,* which consists of spontaneously splashing the surface of the canvas with paint, without a predetermined scheme, so that it becomes a "place of action" and not merely a reproduction of reality. The action is what matters—that is, the physical act of painting is more significant than the result itself.

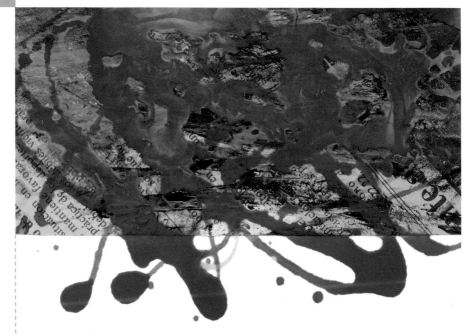

Action painting gives more importance to the making of the painting than to the painting itself. It is a creative method, rather than a style or an attitude.

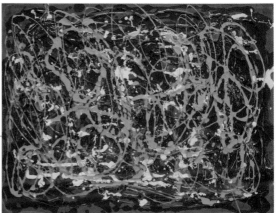

Dripping consists of letting the paint fall from a certain height, allowing it to spill to create gestures of color.

Dripping Paint

Dripping is done on a canvas that is laid flat on a table or the floor. The paint is going to be applied without a single brushstroke. The brush is submerged in a container of fluid, liquid paint with a creamy consistency. Then the brush is shaken and moved around above the canvas so that it drips paint in curved and parabolic shapes. The bristles of the brush never actually touch the surface of the support; they are held above so the watery paint falls freely. Once in a while the brush can be shaken vigorously over the surface or the paint can be flicked from the bristles.

If you work on wet paint, you will achieve surprising blending and mixing effects.

Filling the Surface

These forms are created by making quick and brusque movements with the whole arm. The applications can be combined with pouring paint directly from the cans, especially if you are working on a large surface. As you paint you must move around the perimeter of the canvas to even out effects on the entire surface. The color and forms fill the space so tightly that they produce a very dynamic, vibrating effect.

The use of large brushstrokes and splashes of paint will create a very dynamic abstract painting that expresses the action of the mind over the muscles of the body.

Transparency and Puddling

Any painting medium can allow you to play with the transparency of color when you work with superimposed washes. These create a subtle, quite poetic, and very atmospheric finish on abstract paintings. The key to working with transparent paint is

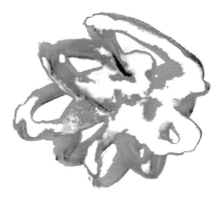

Dry glazing is a specific type of glazing done with a dry brush. It consists of working with thin layers of paint that do not completely cover the surface so as to allow the previous layers of color to show through.

Washing will totally or partially eliminate acrylic paint at various stages of drying. It can be done with a brush or a sponge and water.

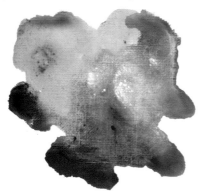

Here paint is applied flat, very diluted and in a large amount to form puddles that distribute the paint irregularly to create organic forms.

If you wash color over a canvas that was first treated with modeling paste, you will create an effect with strong surface relief.

waiting for it to dry so as to allow more layers of washes that don't cause the colors to mix or be altered. Here we have gathered a small catalog of very useful effects that can be incorporated into abstract paintings.

When two incompatible mediums like water and turpentine are mixed, it creates a splotchy distribution of the paint.

Rubbing the bristles of a toothbrush charged with paint will cause a rain of tiny drops that will cover the surface in a more or less homogeneous fashion.

Varnish is typically used for finishing traditional paintings; however, in abstract painting it becomes a powerful medium for creating transparencies and glossy areas.

A sponge roller can be used for applying flat and homogeneous areas of diluted paint. It is very practical for quickly painting large surfaces.

Antoni Tàpies

(1923)

Tàpies is considered one of the greatest Spanish artists of the twentieth century. In 1951 he

Tàpies created a style that combines textures with graphic symbols.

To demonstrate Antoni Tàpies' style of painting we used his work *Blanca* (1984) as a model. This is a drawing of a large white letter M on a nearly black background. The first thing that calls your attention is that the form was created with heavy impasto paint, applied with a spatula, with a great number of gestural lines. The variety of techniques (impasto, glazing, flat painting) and graphic approaches (brushstrokes, sgraffito, spray paint) add strong graphic interest to this work.

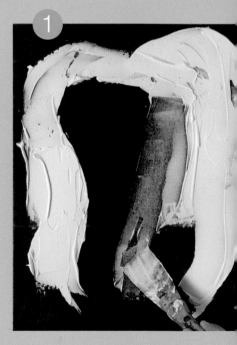

1. We will try to reproduce the painting process of the artist combining the same materials, although we are going to add a note of red paint so that the final result does not look exactly like the model. We begin by applying a generous quantity of fine modeling gel on a support covered with dark acrylic color. This is spread with a spatula.

traveled to Paris, where he came in contact with Informalism, an abstract movement of which he became the main champion. From that time on, his work was characterized by mixed media. For example, he often used paint mixed with sand and marble dust. In short, he liked to mix heterogeneous elements with paint applied directly from the tube in the form of thick impastos worked with brushes, incisions, lines, and grooves. Tàpies used his fingers, sticks, knives, and many other instruments. The final goal was always to create a painting with volume, and especially interesting textures.

CREATING WITH VOLUME AND TEXTURES

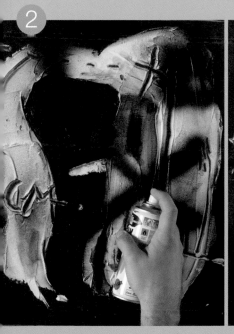 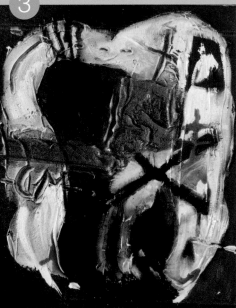

2. *The artist makes marks and sgraffiti with the rounded tip of a spatula while the modeling gel is still fresh. Then the gel is left to dry for a day. The next morning work is resumed, covering the surface with a black spray fixative.*

3. *The spray-painted lines are then outlined with thick white oil paint. Two pieces of wrinkled canvas are glued on with latex, and painted with cadmium red. To finish, a large amount of varnish is poured on the flat surface to form a puddle, and some symbols are drawn with the handle of the paintbrush. The painting is placed on a flat surface and left to dry.*

Glazed Tones

This multicolored group of boats is a good excuse for making a painting that will not have any figurative reference, even though it will inspire some aspects of the work.

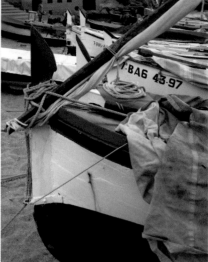

1. Do not make a preliminary drawing. Using a wide palette knife, make just four strokes of blue, yellow, red, and green that have been very diluted with water.

2. When the previous washes have dried, cover the background with somewhat brighter new glazes of red, orange, and pink. Little by little you are brightening the colors by overlaying washes.

3. Add more opaque paint over the glazes in the center with a metal spatula. If you press hard the layer of color will be very thin.

Glazes are applications of very diluted, transparent paint that allow you to see the colors that were painted underneath. Success in working with this technique depends on the artist's ability to control the washes, varying the transparency of the colors and combining them with blending and gradations. Glòria Valls did this exercise with acrylic paint, because not only does it dry quickly but the colors become permanent and insoluble. This allows you to add successive glazes on a surface knowing that the new colors will mix with the ones underneath.

5. Several layers of overlaid glazes were necessary to create the final tones. The color seems more intense when it is wet than when it is dry. For this reason you must be careful not to dilute the paint too much, since the final work might seem dull and pallid.

4. Work on the edges and the contrasts between each band of color with a smaller round brush. They will look less diluted and a little bit brighter.

Scraping the Paint

When making an abstract painting it is important to know many techniques that can be used at the opportune moment. Many different and varied techniques often coexist very discreetly in a single work of art without affecting its style. One popular alternative to brush painting is sgraffito. Sgraffito refers to removing fresh paint from a work's surface, thereby creating interesting strokes and lines.

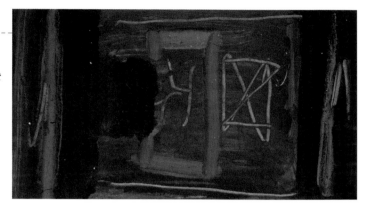

Sgraffito can only be done when the paint is fresh. It adds graphic interest to a work that has too many areas of flat color.

Use the tip of a spatula to make linear sgraffito.

If you scrape the paint with the edge of the spatula you will create wider openings in the paint.

With the edge of a serrated knife you can make sgraffiti in a grid of fine lines.

Sgraffito

This technique consists of removing part of the wet paint from the surface of the work with a sharp or pointed instrument. It works best when you are working with two layers of different colors. Once the first layer is very dry apply a second, thicker one over it. Then you do the etching or sgraffito so that the first layer shows through again. If you scrape with the edge of a spatula you will get wider openings, while if you use an awl or the tip of a spatula the sgraffito will be linear.

Scraping and Eroding the Surface

There are two basic ways of handling this technique: with either a wet or dry layer of color. In the former, the wet paint can be scraped with stiff brushes, metal brushes, serrated scrapers, and even combs. In the latter, you must erode the surface of the painting, scraping it with sandpaper to let the colors underneath show through. The resulting texture is reminiscent of the surfaces of aged paintings.

Cover a background of several different colors with a thin layer of white oil paint. The surface can then be eroded with sandpaper to create a worn looking surface.

Using the tip of a craft knife make very fine subtle sgraffiti to improve the results.

Styles and Interpretations

Abstract painters use the styles of modern art as a means and not an end, and they abandon norms and prejudices so that they can relate forms and theories that in the recent past were thought of as mutually opposed. This means that abstract paintings are the fruit of mixing different painting techniques and even artistically distant styles on a single support. A variety of forms and colors are mixed in these paintings according to the intentions and expression of the artist. Any combination is acceptable if the resulting painting is good. But be careful, not everything is acceptable—to successfully juggle all these factors it is important to first make a few personal forays into different styles. This practice will help you expand your visual resources and form a sense of aesthetics, so you can create the most effective interpretation of each subject you tackle.

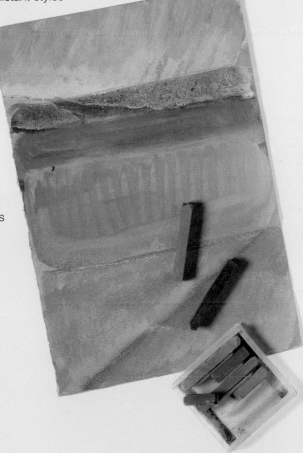

Dragging

This technique, which is also called "combing," refers to creating textures by dragging flat or serrated tools across wet paint. Working with the edge of the blade of a flat spatula while applying pressure results in thin layers of paint with mixed streaks of color.

Dragging creates a grained effect. This is achieved by dragging a layer of wet paint with a spatula over a previously applied base of another uniform color. If you press hard with the spatula when you drag it, the top layer of paint will become very thin creating an effect much like glazing.

The background is prepared with a flat metal spatula dragging in two overlapping directions (a). More combing is done on this dark background to make new grainy effects and a dominant violet color (b). The final dragged texture should contrast the most. Although this method of working uses up a great deal of paint, the wide range of possible effects justifies the splurge (c).

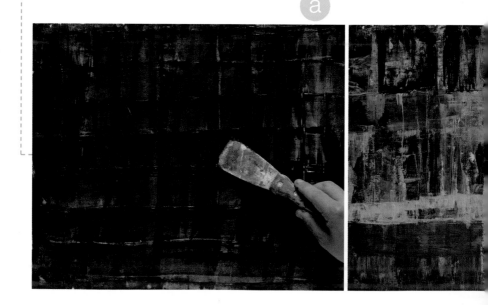

Composition with a Metal Spatula

We are going to paint an abstract composition by dragging the paint with a large metal spatula. Notice how the resulting consistency and thickness vary depending on the tool that we use and the opacity and fluidity of the paint. It is possible to obtain very different effects depending on whether the spatula is dragged straight, diagonally, or in a curved pattern. You can also superimpose layers of color by dragging in two directions on the same surface. The dominant layer will be the last one and it will consist of a mixture of white, black, and sienna, colors that contrast vividly with the dominant violet tones of the background.

The paint is spread by dragging, forming bands, which can be distorted by moving the spatula in a zigzag pattern.

If a spatula with a straight edge is used instead of one with a toothed edge, the dragged paint will look striated and will have lines and grooves that are very visually interesting.

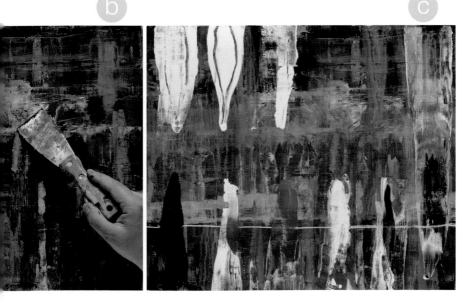

b

c

Informalist Painting

This style of painting rejects geometric shapes and compositional rules that are too strict, and favors an interpretation based on organic forms with an emphasis on reliefs and the material aspect of the paint. This goal is achieved by increasing the tactile sensibility of the painting's surface and by incorporating different textured materials into the painting.

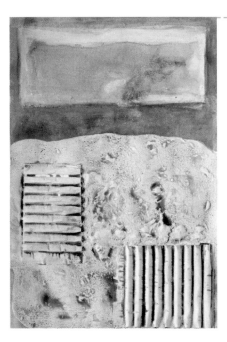

An Informalist painting does not look like any particular real subject, and it is based on the relief effects produced with the paint.

Since this technique is based on the accumulation of paint and relief, it is possible to add most any type of material to the painting.

Fabric is adhered to the support with generous amounts of latex; this causes wrinkles to form, which creates an even greater relief effect.

Intuitive Composition

An Informalist interpretation does not require thorough planning of the composition; oftentimes it is random and improvised. It consists of arranging forms, colors, and materials on the canvas until a pleasing visual effect is achieved. Therefore, this style makes it possible to explore new forms of expression based on intuition, without having to conform to a real model.

The Importance of the Materials

Artists are not limited to the paint on their palettes—they can use any type of material: sand, glass powder, straw, marble dust, resins, glues, and so on. Generally, artists use natural materials or non-processed industrial materials selected and arranged based on their texture. They are adhered to the canvas and covered with paint so they become integrated into the painting to form a unity.

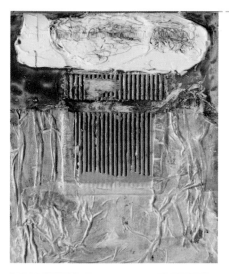

Different materials are combined to prepare the canvas: corrugated cardboard, modeling paste, straw, and rags.

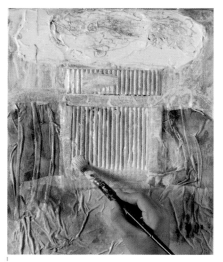

To make the paint adhere better we apply a layer of white gesso over all the materials, with the exclusion of the drapery.

When the primer is dry, we paint each surface with a different color. To finish, we draw a few graphic symbols with a charcoal stick.

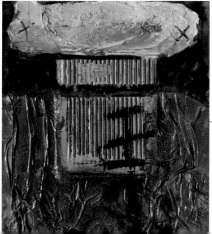

Geometric Constructivism and Harmony

The aim of this style is to strip art of any unnecessary element with the purpose of exposing the essence of the medium through an objective plastic language. It is the ultimate abstraction, based on an analysis of an object's internal structure and on the reduction of primary colors. The simplicity of this approach has had great influence in twentieth century architecture and design.

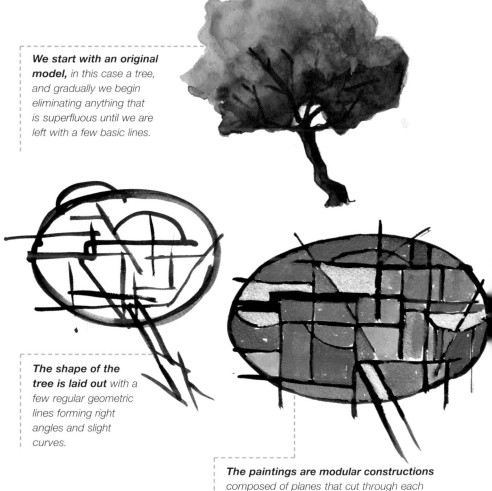

We start with an original model, in this case a tree, and gradually we begin eliminating anything that is superfluous until we are left with a few basic lines.

The shape of the tree is laid out with a few regular geometric lines forming right angles and slight curves.

The paintings are modular constructions composed of planes that cut through each other vertically and horizontally.

Maximum Synthesis

The geometric paintings here have their origins in Cubist painting, although the approach is much more streamlined. They follow a gradual process of abstraction by which the forms are reduced to a few shapes accompanied by horizontal and vertical lines. The synthesis of the forms also conforms to the color, which is reduced to basically three or four primary colors, in addition to black and white. The goal is to give more clarity and precision to the painting.

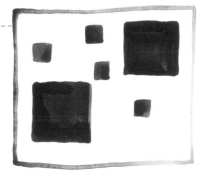

When composing with simple geometric shapes it is important to keep the balance of the painting in mind. This means that a large form has to be compensated with another one that is similar or the same to strike a balance.

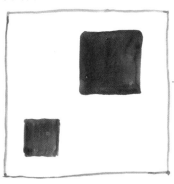

In the space of the painting the larger shapes will be placed on the upper part. They can be balanced with other smaller ones on the lower part of the box.

The same is true for colors. The painting appears more balanced if warm colors are placed in higher positions than others with cooler tendencies.

A painting done in this style is devoid of any emotion; it is driven by a mathematical rigor and the radical simplification of geometry.

Repetition and Rhythm

Repetition in abstract painting is used with three basic objectives in mind: to create a sequence of rhythm, to achieve a decorative effect, and to even out the surface of a painting. Current painters interested in the effects of repetition, in modular art, or in working in series tend to focus, more than on any other criteria, on regularity and repetition.

In abstract painting it is very common to use patterns. They could be a series of lines, forms, tonal accents, or even brushstrokes.

The repetition of graphic elements consists of symbols and forms painted over and over again.

Repetition illustrated with brushstrokes is achieved by always painting in the same direction.

Using Patterns

Patterns respond to a sense of finality in construction or design. They are associated with exuberance and vitality and with a determination to enjoy life. Repetition or pattern is a form of superficial ornamentation. A variety of forms can be achieved with repetition, as well as a sense of harmony, and a continuous visual order. Besides their decorative value, repeating drawings often suggest the form by way of changes in the direction of the lines. Repetition also adds dynamism to the surface of the painting.

Repetition of Colors

Colors contribute to the effects of repeated lines and forms since the contrast they provide facilitates a clearer understanding of the patterns. Repeating colors close to each other creates an optical combination producing an effect of a continuous color surface. This is reminiscent of the succession of forms and color motifs often seen on fabric prints. Consider the patterns you see on clothing and fabrics, and the decorative motifs on textiles, wrapping paper, or drapes.

The repetition of a sequence of shapes gives the painting a sense of rhythm.

A chromatic repetition is achieved by the orderly repetition of colors.

The consistent repetition of lines, forms, or fields of color can make a painting appear as if it were in constant motion.

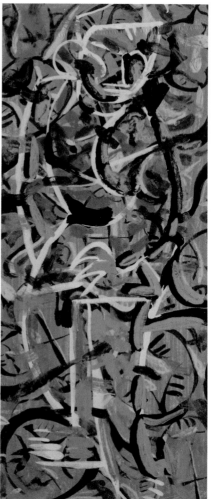

A Diptych with Texture

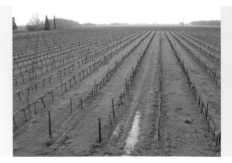

The perspective lines in this field are going to be the focus of this composition since they will become the structural axis of this exercise.

1. Select two canvas boards of similar size. Old canvases can be recycled but you will have to cover them with paint first.

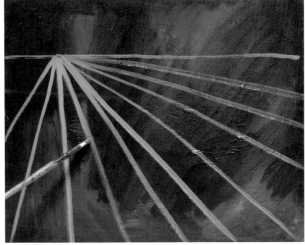

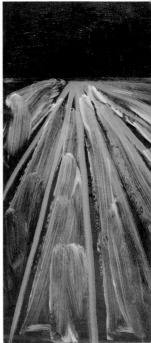

2. Draw the first lines over the oil background once it is dry. These are the diagonal lines of the field that converge at a single vanishing point on the horizon.

In many cases, the fact that abstract painting is not strict or neat is an advantage for tackling daring and expressive themes. With a high level of abstraction, however, a painting's texture, composition, and chosen format will play key roles. For example, it is possible to work on supports that are not pristine or to choose formats that are not common in realistic painting. The following exercise demonstrates this freedom of expression since the goal is to paint a diptych, two canvas boards side by side. There is no need to buy supports since recycled ones work well. The painting is by Gabriel Martín.

3. In the beginning it is wise to work on each board separately. Prepare a textured base to represent the relief of the sown fields. To do this use modeling paste applied generously with a medium round brush.

4. On the other support the horizon line is angled and the initial orientation is vertical. The texture is created with a filler of black volcanic sand that is sold already mixed and ready to use. Scratch the surface with the spatula while it is still wet.

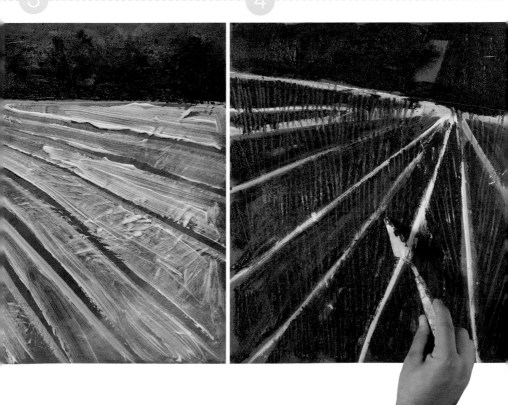

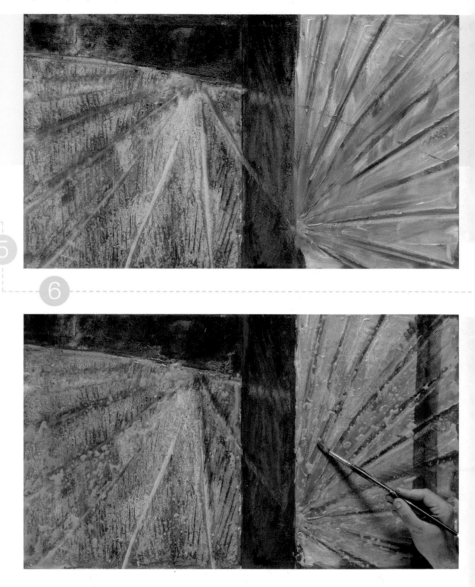

5. Let the texture of the boards dry for an entire day. After this, put the two boards together so you can work on them at the same time. The fields are painted with diluted green oil paint, so it penetrates the cracks easily. Leave a black band in the middle where you can paint a few orange brushstrokes.

6. Paint the central band and outline the upper angles of the painting, as well as a few furrows in the fields, with cadmium red. Dilute acrylic paint with water and apply it over the painting while the oil paint is still wet. The oil paint and the water will react, causing the paint to run and form very interesting puddle effects.

7. Outline the lines of each row with a stick of black pastel and darken the already dark bands. Since the surface is very textured, the pastel lines look broken and very spattered. When working with pastel you do not need to wait for the previous washes to dry; it looks even better if the paint is fresh.

8. Dip a natural sponge in very light blue oil paint. Press it lightly on the darkest areas of the painting to create a gray patina that makes the texture stand out.

9. Using a thin brush charged with black oil paint, add a few lines to the support on the right, and make several zigzag lines with chalk. After adding a few highlights with red pastel, this diptych, presenting a very free interpretation of the original model, is finished.

Painting Without a Brush

Not all the effects of abstract painting are achieved with a brush; it is important to learn how to work with and manipulate other materials that require different application methods. Tools that are not normally associated with the world of art can be used to create unusual effects that add tension and evoke different emotions. Here we will explore a few examples of effects created without a brush.

Paint over a support that has been previously covered with a layer of solid color and create areas of light with a rag to let the color underneath come through.

A repetitive effect can be created on a surface by using any object as a stamp. Dip it in paint and apply it as many times as needed to leave an imprint.

When you have several layers of superimposed paint, all dry, the surface can be sanded. The erosion allows the colors underneath to peek through and blend with the surface.

Sponging consists of dabbing the surface of the painting with a paint-charged sponge. This technique results in a mottled effect.

Dripping or extruding paint refers to applying paint directly on the support through a tip attached to the tube. This will give volume to each line of paint.

Charge a brush with diluted paint and hold it high over the canvas letting the paint drip. The higher the distance from the plane of the painting, the more the paint will splash.

Cover an area with liquid glue or latex. Then sprinkle pigment or sand over it so it will adhere.

Aerosol paint lets you create sprayed effects and lines with blurred edges.

Using oil pastel sticks you can incorporate lines without using a brush. The result is thick and may even look like an impasto.

THE SUBJECT

Minimal Expression

In this segment we are going to study paintings that have been through an intense process of synthesis in which all superfluous elements have been eliminated to arrive at the most basic level. In certain cases the work is only a sketch, a simple gestural line applied with a thick brush. In other cases, the canvas is covered with two or three bands of solid color with very well-defined outlines.

The gesture becomes an object whose significance is simply itself.

With this drastic reduction of elements, the painting attempts to express and to stimulate ideas and emotions, whether those of the artist himself or the spectator. With such a daring pictorial approach, a reaction on the part of the viewer is sure to emerge.

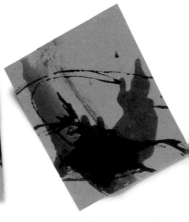

Painting with a Wide Brush

Paint a line with a thick brush on a colored background or a white canvas— an unbroken line without lifting the brush from the surface, spontaneously, trying to create a continuous dynamic to catch the attention of the spectator. With this technique, it is very important to work with thick and abundant paint, so that the brushstroke is well defined. Practice making different types of markings while keeping various factors in mind: the concentration and dilution of the paint; the thickness or thinness of the lines; and the pressure and speed used.

Primary Color Structures

Minimal expression of color and form are hallmarks of Minimalist paintings. This type of abstract art is inspired by rectangular and cubical shapes, which do not represent anything in particular. The different shapes are reduced to minimal states of order and complexity from the morphological point of view. The paintings are characterized by large areas of flat color, painted on neutral surfaces where brushmarks disappear completely. Minimalism is reminiscent of industrial painting techniques which are known to produce an immediate visual impact.

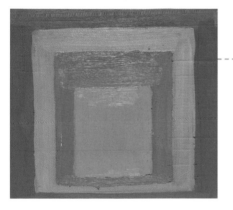

Minimalist paintings personify maximum states of order with the minimum selection of colors.

They are painted on large format canvases where areas of flat color, with neither gradations nor brushstroke marks, are the predominant feature.

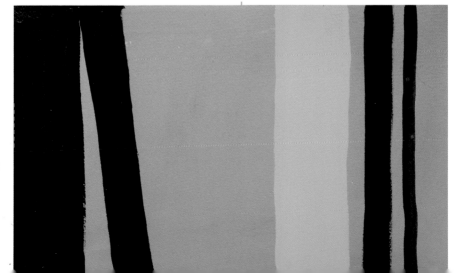

Expressive Brushstrokes

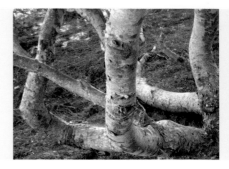

The quiet corner of a forest, where the tree trunks are whimsically intertwined, is the focus of this exercise. Our job is to add color to it.

1. *The support is covered with raw sienna. Acrylic paints should be used because of their fast drying time. Over that background the shape of the tree is laid out with firm and deliberate strokes.*

① ② ③

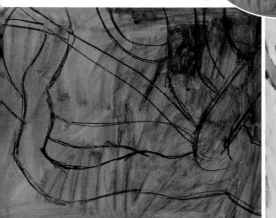

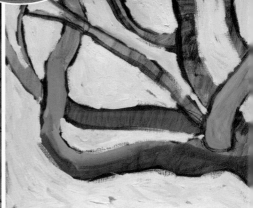

2. *The first colors of the tree trunk are painted with green and magenta. Ivory black is used to highlight the outlines of the main forms.*

3. *Next, oil paints are used. Martín paints the background with a large amount of titanium white, adding light dabs of blue and yellow. The paint is applied as an impasto to allow the marks of the brushstrokes to remain visible.*

Abstract painting departs from that almost magical relationship of resemblance that exists between a figurative painting and its model, to embark into another universe, no less magic, in which the spectator is pleased and surprised by a surface made up of energetic brushstrokes. The action of the brush is, therefore, key in the creation of a visually attractive and dynamic composition. Expressive brushstrokes make the finished painting look very fresh, spontaneous, and seem as if it were made in a hurry. This exercise executed by Gabriel Martín. The medium is oil paint.

4. Bright colors are applied to the vegetation with no apparent order. The paint is sufficiently thick for the brushstrokes to be visible. The artist uses a filbert brush because it leaves deeper marks in the paint.

5. The generous and expressive brushstrokes are combined with sgraffito, applied using the rounded tip of a spatula.

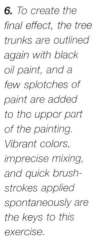

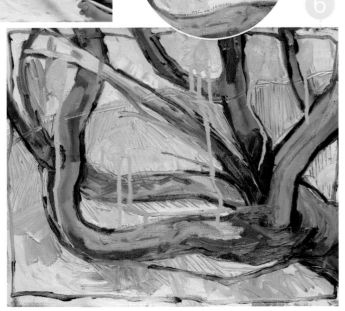

6. To create the final effect, the tree trunks are outlined again with black oil paint, and a few splotches of paint are added to the upper part of the painting. Vibrant colors, imprecise mixing, and quick brush- strokes applied spontaneously are the keys to this exercise.

Color Field Painting

Next we will analyze the pure capacity of the gestural use of color as a qualitative tone, as a determining factor of space, or as a value of light. We will focus solely on color and its possibilities for expression, putting aside form and graphic elements, since the idea here is to analyze color in its purest state, and explore its possible combinations and contrasts.

Both squares are identical, but the one on the left blends better with the background; this is achieved by blurring its edges.

It is a good idea to make small compositions that allow us to explore the expressive potential of color fields.

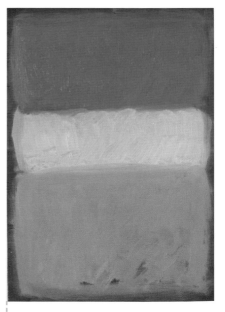

Color field painting is characterized by canvases that are nearly filled with blocks of color with blurred edges, created by applying layers of oil paint with delicate brushstrokes.

Limited Colors

Drawing and form are applied in a simple manner, so that color can take center stage. The chromatic application is usually limited to only a few colors since the goal is not to produce a colorist painting but to experiment with the relationships that are established between two or more colors or between others derived from them.

A Spiritual Feeling

The goal of these paintings is to appeal to the feeling of the sublime through the perception of color. The tone, value, saturation, translucence, and texture of the colors play an integral part in evoking the feelings that those paintings convey. To test the psychological effect of color upon the spectator, we are going to paint the same theme with the same colors, making small variations to the saturation or contrast. Let's see how these small changes will affect the final harmony of the colors.

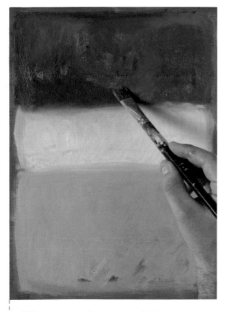

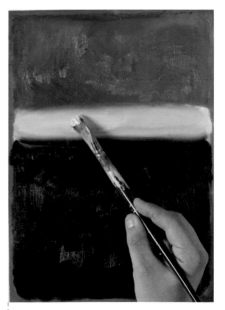

When we replace one of the colors with another, the color relationship of the painting changes completely. The harmony is broken with a contrast of complementary colors.

The harmony between colors is recovered when blue is added. The red background that surrounds the colors becomes stronger and turns, along with white, into one of the brightest areas of the painting.

Four Interpretations of a Theme

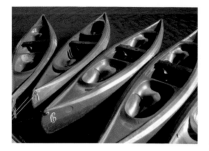

Here we simplify the forms; in other words, we capture the main forms with firm and well-defined brushstrokes. The colors are very synthesized and offer more variety than in the real model.

The support is painted with a mixture of blue, black, and violet colors. We extend an evenly distributed layer of modeling gel over the dry surface. While the paste is still fresh, we define the forms of the boats with sgraffito lines.

The best way to improve abstract painting skills is by working in series, and practicing painting the same model even if it seems repetitive, to explore all the representational and expressive possibilities. For this, it is important to have small boards or sheets of paper to make color sketches and brief studies of any subject matter. We suggest working on a single model and trying different interpretations of it to practice the techniques learned in this book, and to observe how their application affects the final result. Here, we have included a photograph of the real model, for inspiration and to better compare and evaluate the results.

Here is another version. With a straight spatula and the acrylic mixture of green, magenta, and yellow, we paint the background of the support with a dragging technique. When the background is dry, the empty spaces that surround the boats are painted, leaving only their shapes exposed.

We finish with an interpretation that layers fluid paint over bold lines. Varnish lightened a little with white oil paint is spread over a dark background. While the varnish is still wet, we draw in simple lines for the boats with an oil pastel stick.

Gerhard Richter
(1932)

Richter is considered by some critics as one of the most important German artists of the last quarter of

Abstraktes Bild *(1989)*
The originality of this painting lies in the effect produced by thick paint dragged over photographic paper. The technique is simple: Richter drags wet paint with a spatula across a colored background, which is nothing more than a photograph. He places the spatula at the edge of the photo and drags it, even splattering paint at times or creating a zigzag effect with a hand motion. In these painted photographs the author combines the immediacy and freshness of the paint and the spirituality of the photograph to create a dialogue between the two genres.

Richter's interest in color is evident when you consider the extent of the chromatic combinations that he uses. They go beyond what a typical oil paint palette could provide.

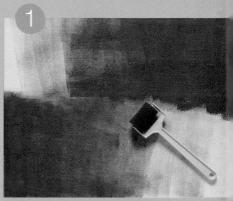

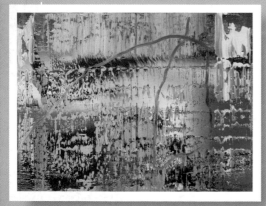

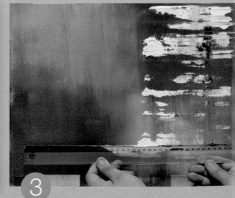

the twentieth century. At the end of the seventies and beginning of the eighties, he made numerous oil paintings with brilliant colors and bold effects that showed his great interest in fillers and daring colors. This style was related to the neo-Expressionist movement popular at the time.

His other works from this period are full of tension between the represented reality and the actuality of the paintings. In them, the process—which included impastos and dragging effects using large amounts of paint—became as important as the paint itself.

1. Instead of working on photographic paper, here we have prepared the background with acrylic paint. The paint is applied with a roller to make smooth gradations.

2. Magenta and cyan are applied with the roller. The transitions between both colors are softened with a wide soft-hair brush.

3. A plastic ruler dipped in thick yellow, white, and green oil paint is dragged over the surface, which is already dry. The paint adheres to it unevenly and irregularly.

4. We drag the ruler again, but this time horizontally, using yellow, green, white, and red colors, and covering the background only partially. To finish, the same green used in the dragging process is brushed on, creating a large graphic element.

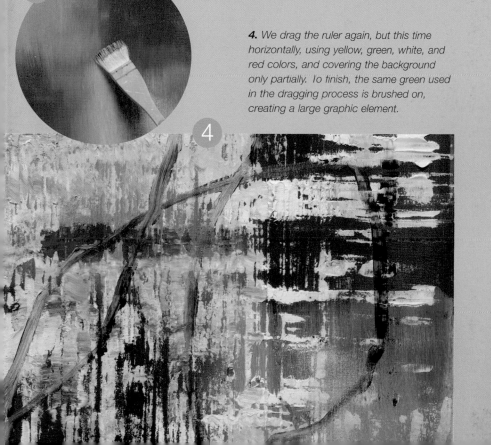

"In our paintings, we can see areas of color and lines that do not conform to any reality, but that musically—responding to our innate mathematical law—prepare and intensify the emotion. Therefore, we look instinctively for the connection between external concepts, for things that are concrete, and for the intimate and abstract emotion. Those lines and areas of color, which seem illogical at first sight, are the mysterious key to our paintings."

Boccioni, Carrà, Russolo, Balla, and Severini:
Preface to the first exhibition by Futurist painters in Paris, 1912.